Happy Chinese Calligraphy6

THE DIAMOND SUTRA

The Vajracchedika-prajna-

paramita Sutra

Panda Pen

隸書為書法常見的字體之一

是漢字中常見的一種字體風格

書寫效果略微寬扁

講究「蠶頭雁尾」、「一波三折」

隸書起源於秦朝

在東漢時期達到頂峰

Lishu is one of the common fonts for calligraphy

Is a common font style in Chinese characters

The writing effect is slightly wider and flat

Pay attention to the "head of wild goose" and "a wave of twists and turns"

Lishu originated in the Qin Dynasty

Peak in Eastern Han Dynasty

金剛經

THE DIAMOND SUTRA

金剛般若波羅密經

The Vajracchedika-prajna-paramita Sutra

一切有為法

如夢幻泡影

如露亦如電

應作如是觀

All phenomena are like a dream, an illusion, a bubble and a shadow, Like dew and lightning. Thus

should you meditate upon them."

一切有為法如夢幻
泡影如露亦如電應
作如是觀

一切有為法如夢幻泡影如露亦如電應作如是觀　金剛經

二〇一九年己亥仲春梁來戴恭書

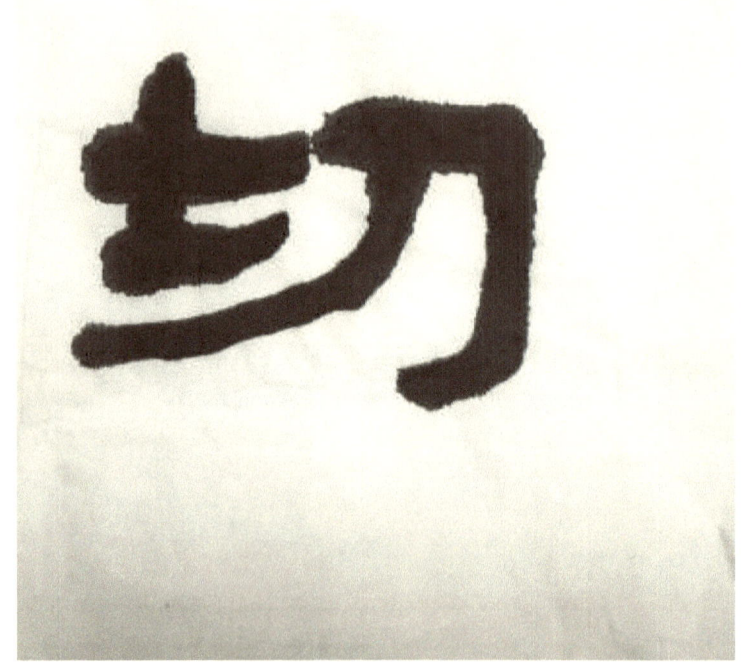

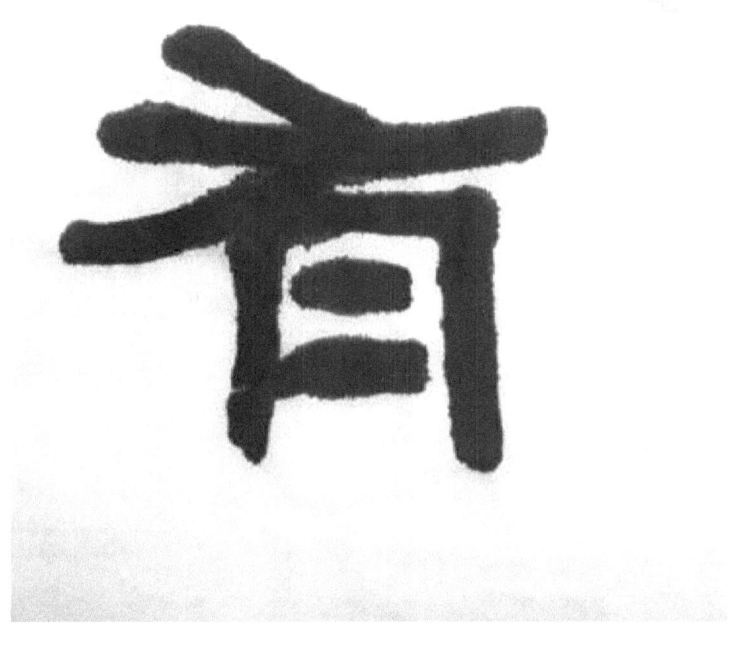

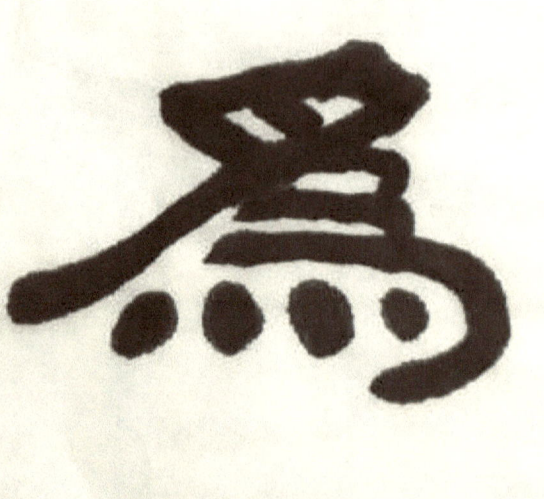

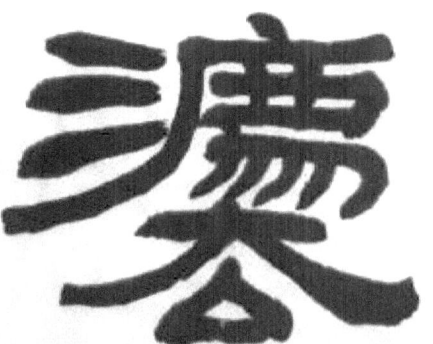

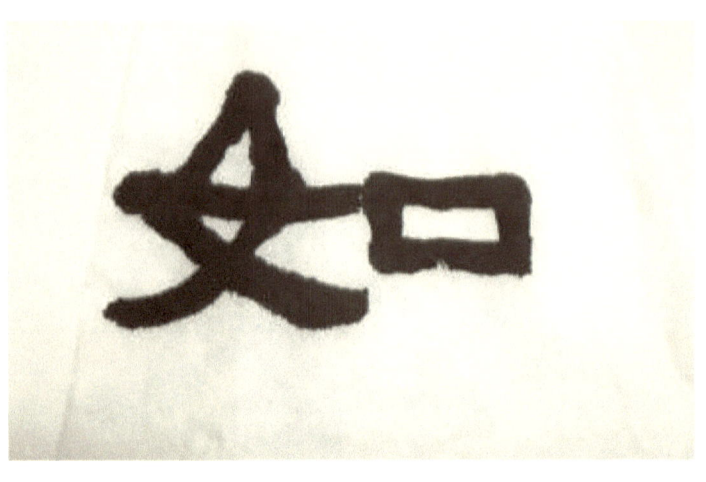

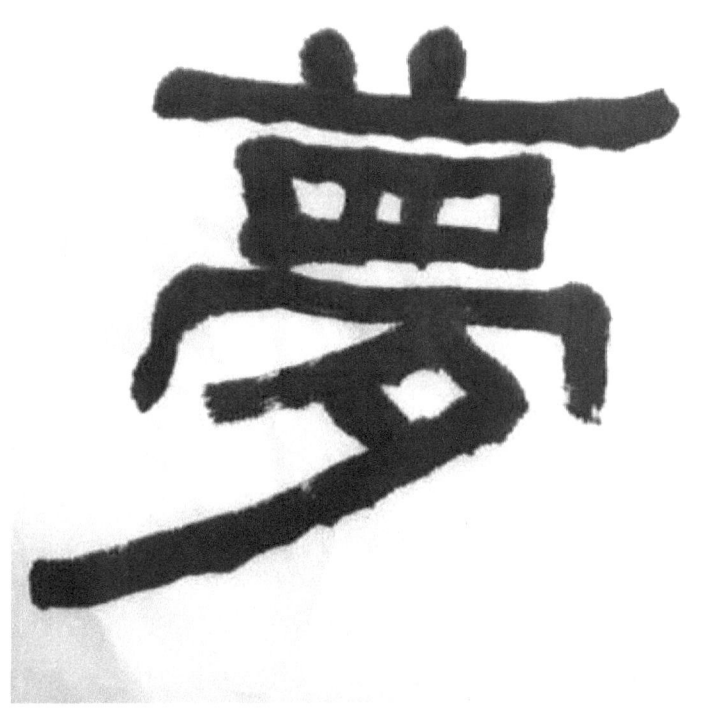

司

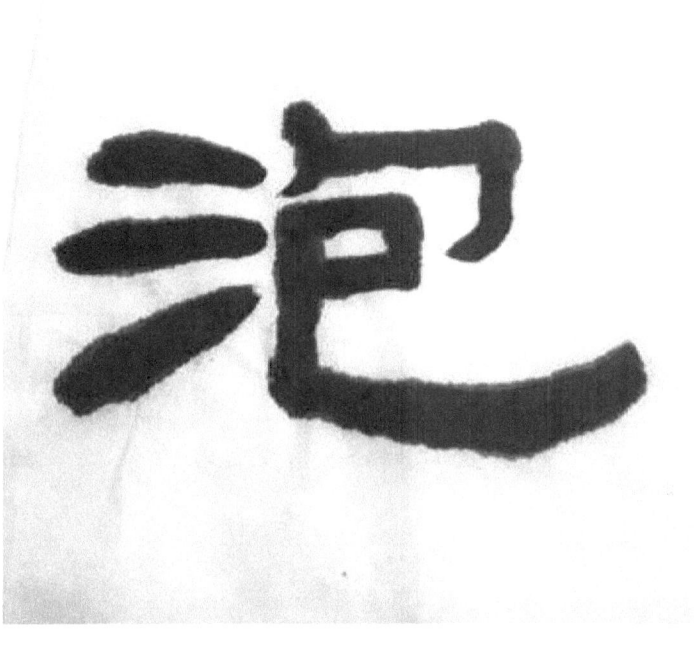

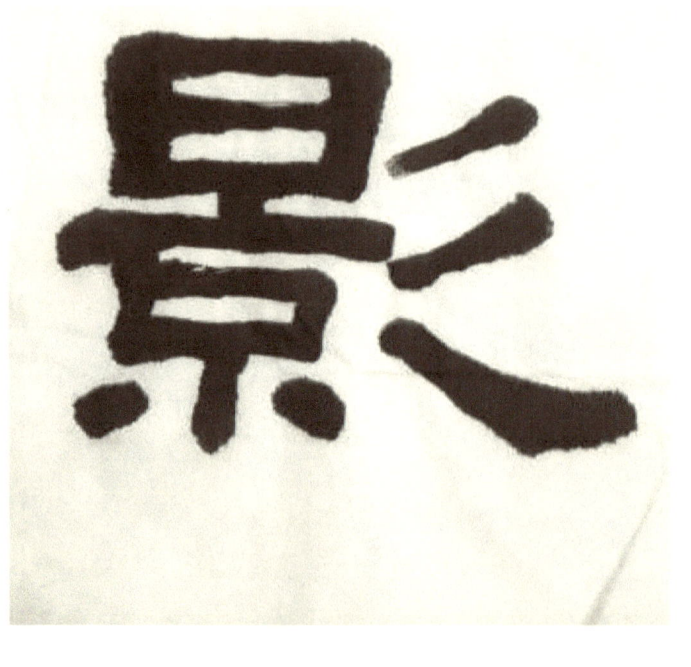

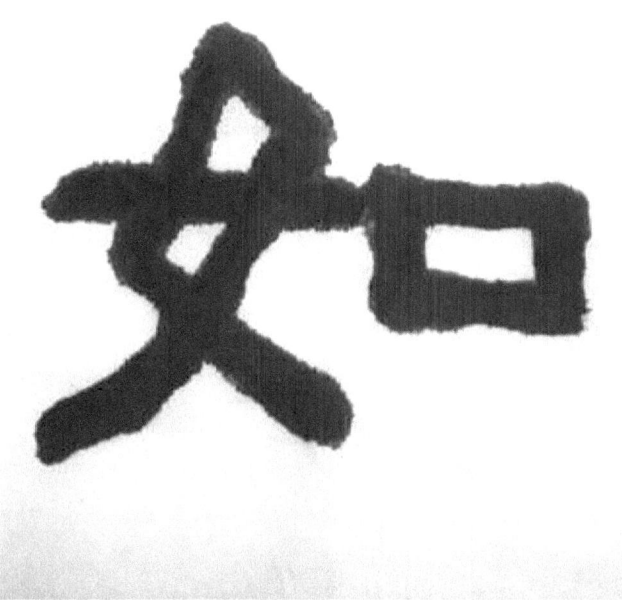

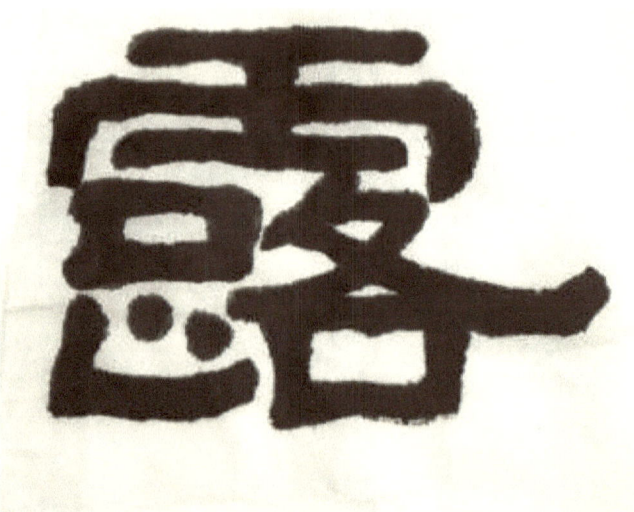

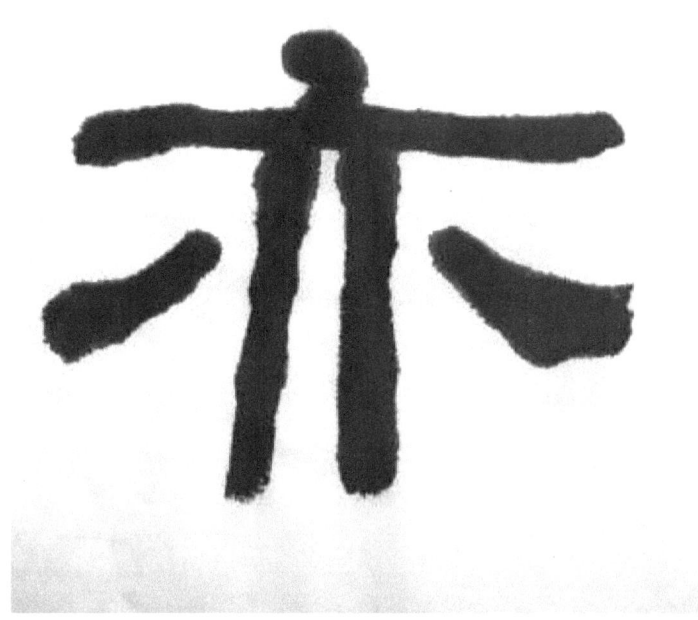

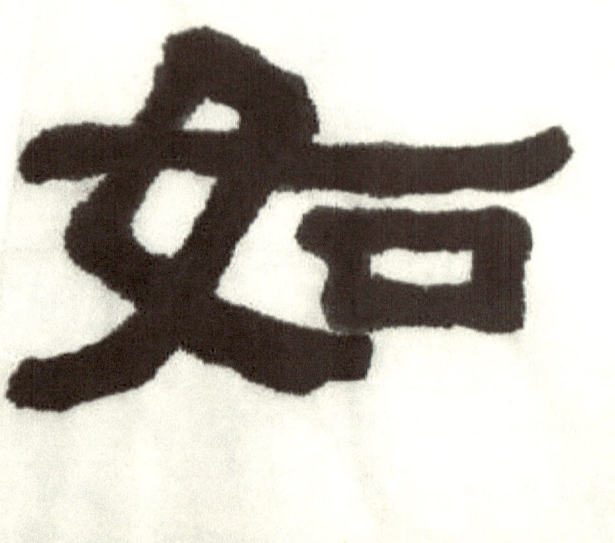

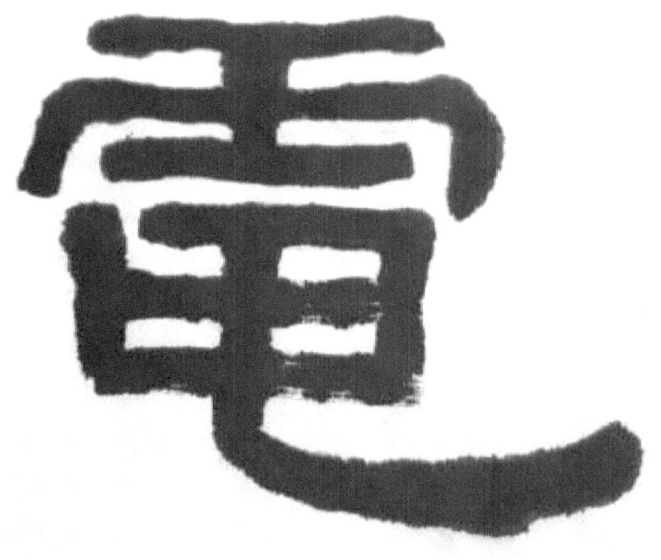

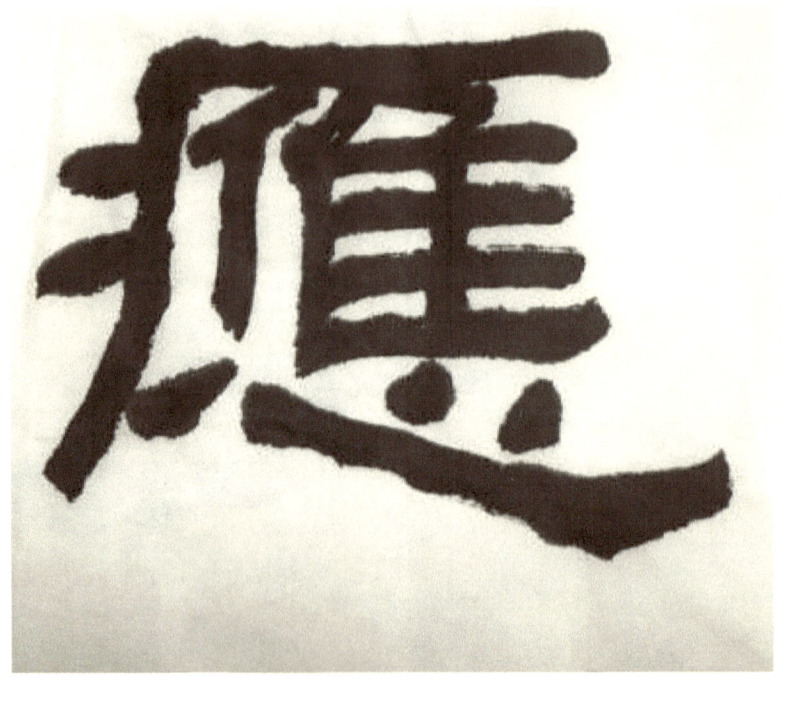

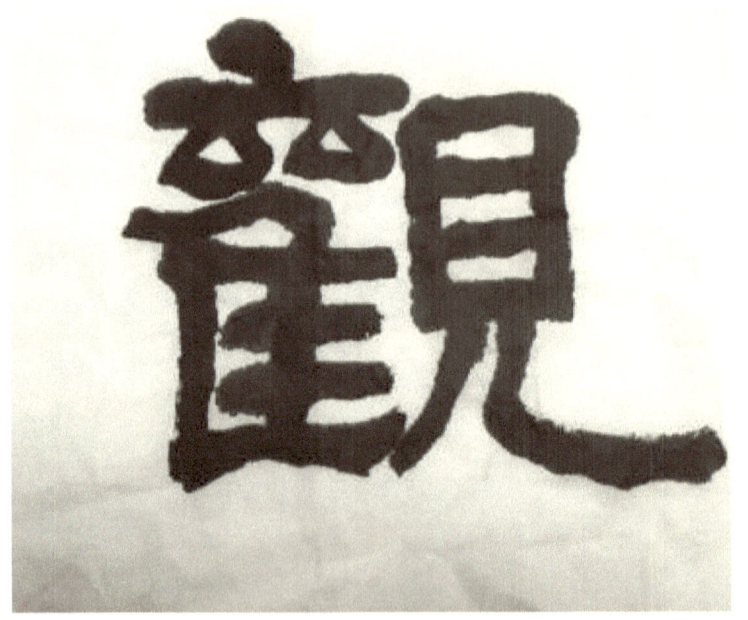

一切有為法如夢幻
泡影如露亦如電應
作如是觀

一切有為法如夢幻泡影如露亦如電應作如是觀 金剛經
二〇一九年己亥仲春 漢東戴恭書

Happy Chinese Calligraphy6

Panda Pen

www.ingramcontent.com/pod-product-compliance
Lightning Source LLC
Chambersburg PA
CBHW031940170526
45157CB00008B/3262